Point and Shoot

Digital Photography Basics for Beginners and Amateurs

Master your DSLR in 21 Days

By Michael Hansen

Dedication

Dedicated to all my students who encouraged me to write this book.

Table of Contents

Dedication ... 2
Disclaimer ... 8
Introduction .. 9
Chapter 1 .. 10
Introduction to the Different Qualities of Digital Photos ... 10
 Bit Depth .. 11
 Sharpness .. 12
 Image Noise .. 13
 Dynamic Range ... 13
Chapter 2 .. 14
Basic Terminologies in Digital Photography .. 14
 Megapixel .. 15
 ISO ... 15
 Aperture and F-Stops ... 15
 Depth of Field ... 15
Chapter 3 .. 16
Types of Cameras .. 16
 Comparison .. 17
 Viewfinder Mechanism .. 17
 Interchangeable vs. Fixed Lenses ... 17
 Camera Sensor ... 18
 Other Minor Advantages and Disadvantages ... 19
 Compact Camera .. 19
 SLR Camera .. 19
Chapter 4 .. 20
Camera Accessories .. 20
 Tripod .. 21
 So When Do You Need To Use A Tripod? ... 21
 Other Common Uses for a Tripod ... 21
 What to Consider Before Buying a Tripod ... 21

Camera Flash ... 22

Chapter 5 .. 24

Camera Lenses .. 24

Focal Length .. 25

Prime vs. Zoom Lenses .. 25

Closer Look at Wide Angle and Telephoto Lenses .. 25

Wide Angle Lenses ... 25

Telephoto Lenses ... 26

Macro Lenses ... 26

Camera Lens Flare ... 27

Camera Lens Quality ... 27

Chapter 6 .. 28

Maintenance ... 28

Cleaning and Taking Care of your Camera Sensor .. 29

Tips on How to Keep Your Sensor Clean ... 30

Chapter 7 .. 31

Digital Photography Techniques and Styles ... 31

Proper Camera Usage .. 32

Shutter Speed Creativity ... 32

Conveying motion .. 32

Panning and Moving with your Subject ... 33

High Speed Photography and How to Freeze Time ... 33

Other Creative Ways .. 34

More Tips .. 34

Camera Shake and How to Reduce It with Hand Held Cameras 34

Increasing Shutter Speed ... 35

There are only 3 ways to increase your shutter speed: ... 35

Tips on Improving Your Hand-Held Technique ... 35

Plant Your Feet Firmly .. 35

Get a Grip ... 36

Shutter Button Mastery ... 36

Quick Fire Shots .. 36

- A Couple More Tips .. 36
- Chapter 8 ... 37
- **Capturing Your Subject** ... 37
 - Macro Photography Techniques and Tips ... 39
 - Night Photography Technique and Tips ... 40
- Chapter 9 ... 41
- **Lighting** .. 41
 - Making Use of Natural Light .. 42
 - Notes for Time of Day ... 42
 - Notes for Weather Conditions ... 42
 - Tips on Portrait Lighting .. 42
 - Portrait Lighting: One Light Source .. 43
 - Apparent Size: Soft Light or Hard Light? .. 43
 - How to Get a Softer Light Source ... 43
 - Rembrandt Lighting ... 44
 - Other Common Styles of Lighting Using One Light Source 45
- Chapter 10 ... 46
- **Composition Photography** ... 46
 - Rule of Thirds .. 47
- Conclusion ... 49
- About the Author .. 50
- Acknowledgements .. 51
- Book 2 ... 52
- Chapter 1 ... 52
- **Introduction to Post-Processing Workflow** .. 52
 - White Balance .. 52
 - Exposure .. 53
 - Noise Reduction .. 53
 - Lens Correction ... 54
 - Vignetting ... 54
 - Distortion .. 54
 - Chromatic Abberration (CA) .. 54

Details ... 55

Contrast ... 55

Framing: Cropping and Rotating Images .. 55

Refinements: Colors and Selective Enhancements ... 56

Resizing ... 56

Output Sharpening ... 57

© 2013 by VM Publishers

Digital Edition

This book is licensed for your personal enjoyment only. This book may not be re-sold or given away to other people. If you would like to share this book with another person, please purchase an additional copy for each recipient. If you're reading this book and did not purchase it, or it was not purchased for your use only, then please purchase your own copy. Thank you for respecting the hard work of this author.

All Rights Reserved. No part of this book may be reproduced in any form or by any electronic or mechanical means including information storage and retrieval systems without permission in writing from the publisher, except by a reviewer who may quote brief passages in a review.

The content of this book has been reviewed for accuracy. However, the author and publisher disclaim any liability for any damages, losses, or injuries that may result from the use or misuse of any product or information presented herein. It is the purchaser's responsibility to read and follow all instructions and warnings on all product labels.

For information, please contact the author by email at vmpublishers@gmail.com.

Disclaimer

Although the author and publisher have made every effort to ensure that the information in this book was correct at press time, the author and publisher do not assume and hereby disclaim any liability to any party for any loss, damage, or disruption caused by errors or omissions, whether such errors or omissions result from negligence, accident, or any other cause.

Introduction

Digital photography has become easier thanks to technological advancements giving beginners more options and freedom to experiment without having to know everything right off the bat.

Thanks also to the revolutionary changes of technology photography has reached new heights and photographers all around the world are able to take breathtaking images and captivating pictures that wouldn't have been possible a couple of decades ago.

But this doesn't mean that you just have to be contented using the automatic settings. Learning more about photography is a difficult task especially for aspiring amateurs. There are so many things to know and discover in photography that most people are overwhelmed just with the thought of it.

Luckily, I've written this e-book to help beginners like you, to get started on the basics of digital photography at the same time teaching you more complex concepts and techniques as we progress.

So what are you waiting for? Let's get started on this amazing journey of discovery and learn how to master your DSLR in 21 Days!

Chapter 1

Introduction to the Different Qualities of Digital Photos

Before we begin, we need to first understand the different qualities of digital photos. There are many factors that can determine the quality of digital photos, but the most commonly used are bit depth, sharpness, image noise, and dynamic range.

Bit Depth

Bit depth basically tells us how many unique colors are achievable in an image's color palette using the numbers 1's and 0's or more commonly referred to as "bits".

But this doesn't necessarily mean that one image uses all of the unique colors in the palette, but it tells us how precise the colors are in that range.

When it comes to grayscale images, bit depth instead tells us how many different shades are available. For example, an image with a higher bit depth roughly translates to more shades or colors because there are more available combinations of 1's and 0's.

Using the table below, you can clearly observe and compare the total colors available and commonly used names by the different image types when it comes to bit depth.

Bits Per Pixel	Number of Color Combinations	Name(s)
1	2	Monochrome
2	4	CGA
4	16	EGA
8	256	VGA
16	65536	XGA/High Color
24	16777216	SVGA/True Color
32	16777216 + Transparency	
48	281 Trillion	

TIPS

- *Did you know that the human eye can only recognize about 10 million different color variations? With that in mind, using more than 24 bpp (bits per pixel) is too excessive if it is only for viewing.*

- *But images using more than 24 bpp really work well if you use post-processing like Posterization.*

Sharpness

This quality of digital photos simply describes how clear and detailed a photo is. It is very useful for emphasizing texture which is also great for people who are into 3D modeling.

You can use digital photographic and post-processing techniques to greatly increase the sharpness of an image and further enhance its texture.

There are two factors that greatly contribute to an image's sharpness. Those are resolution and acutance.

Resolution simply describes how well your camera can distinguish closely spaced objects between each other and how much detail it can capture. Resolution is limited by your digital camera's sensor.

Acutance is how quickly the image's information can transition at an edge. But this doesn't mean that a higher acutance is equal to having a higher resolution. No in fact, this is all due to the human eyesight's nature that makes it seem that higher acutance images appear to be sharper.

Acutance on the other hand is determined or limited to what kind of post-processing you use and the quality of your lens. Although resolution can be altered before the shot, you can still change or increase acutance even after you take the shot by digitally sharpening it.

Of course you need to have both high acutance and a good resolution for an image to be critically sharp as possible.

POINTERS

- *There are also certain factors that can affect the sharpness of an image like Image noise, which we will be discussing further.*
- *Another factor that affects sharpness is the viewing distance. It goes without saying that the further away the subject is the less sharp it is and will most likely have lower resolution. But at the same time it may appear that the same subject is sharper if you change your viewing distance in a certain way.*
- *Camera technique also contributes to sharpness. Things like reduced camera shake can greatly increase the sharpness of an image. This is why most people always have a handy tripod at their disposal.*

Image Noise

Digital camera image noise or simply image noise is commonly compared to the film grains you see on analogue cameras. Of course for digital images, this noise is usually seen as random speckles on what should be a smooth surface. Image noise can greatly decrease the quality of an image.

But image noise also has some very cool uses such as giving images that old-fashioned grainy look that you often see on classic monochrome films. As stated earlier, image noise sometimes increases the sharpness of an image.

How do you control image noise exactly? Well first off, noise increases with the sensitivity settings of your camera, the length of exposure, and temperature. It also varies from different cameras.

Dynamic Range

Dynamic range is simply the ratio of the minimum (black) and maximum (white) light intensities.

Did you know that in the real world you can never truly see black or white? What you really see are the light source's different intensities and the subject's reflective properties.

How does this exactly affect your image? First things first, each device (camera, scanner, printer, monitor/TV) and even the subject itself have their own dynamic range. So image's dynamic noise could possibly be very different from the camera when transitioning to the printed image.

Using this knowledge you can compare both of them and adjust your settings accordingly to capture the actual dynamic range of the subject or environment.

As stated earlier, dynamic range in the real world is determined by the contrast ratio of the brightest and darkest regions. But this isn't the case with your digital camera since light is measured at each pixel in a cavity or well, called photosite.

Chapter 2

Basic Terminologies in Digital Photography

When venturing into Digital Photography you should at least know the basic terminologies so that you understand what each aspect and factor does and how it affects the finished shot. Of course you should also know the more advanced terms once you go further into your journey as a photographer.

Megapixel

Images are made up of tiny elements called pixels, and megapixel is just a million pixels which is a digital camera's maximum resolution that it can take photos in millions of pixels. So let's say a digital camera has a resolution of 4 megapixels which means that it can only capture up to 4 million pixels in one shot. More megapixels usually translate into higher quality images.

ISO

ISO or the International Standards Organization determines how sensitive your digital camera is to light. If you have a camera that has 100 or below ISO for example, you would probably want to have better lighting when taking your shots. Whereas a higher ISO number like 400 or 800 would mean you can do with less lighting.

Aperture and F-Stops

Aperture determines how much light passes through the digital sensors of your camera. F-stops determine how large the opening of the aperture is. The lower the f-stop, the bigger the aperture opening is.

Depth of Field

Depth of Field sometimes simply referred to as DOF is just the depth of focus of the nearest and farthest object in the scene you are taking the shot. This can be controlled by the aperture. A small aperture will give you a wider depth of field while a larger aperture will narrow your DOF.

Chapter 3

Types of Cameras

Although there are a lot of cameras out there, we will be focusing on the most commonly used and those are the compact and digital SLR (Single Lens Reflex) cameras.

Choosing between compact and digital SLR cameras is probably one of the most important decisions you'll ever make as a photographer, especially when it comes to the financial aspect since it is a very big investment. Of course both have their own unique advantages and as well as disadvantages. So let's get started!

Comparison

There are three main things that you need to consider when comparing compact against the DSLR camera; viewfinder mechanism, fixed and interchangeable lenses, and the camera sensor type and size. There plenty of minor differences like camera brand and model, but the next section will only focus on the three main factors listed above.

Viewfinder Mechanism

The compact camera's viewfinder just estimates what light will hit the camera sensor making it less accurate. There are also some compact cameras that use EVF (electronic viewfinder) that tries to imitate what the SLR's sensor does.

The SLR camera's viewfinder on the other hand uses a mirror (pentamirror or pentaprism) that flips up and redirects the light that was formerly being directed straight to the camera's sensor.

The pentamirror or pentaprism is one of contributing factors why digital SLR cameras are more expensive compared to compact cameras.

TIP: If your work requires you to get exactly the needs to be captured, then there is no doubt that getting a digital SLR camera would be your best choice. But if this is not the case, then you can just use the rear LCD using the live view mode which is available for both compact and digital SLR cameras.

Interchangeable vs. Fixed Lenses

Having the option to change lenses is one of the reasons why digital SLR cameras are so versatile compared to compact cameras. There are certain compact cameras (especially high-end ones) can also use lens adaptors, but the original lens is still in use.

So what is the fuss about having interchangeable lenses? Is it really necessary? There are lots of advantages of being able to switch between different lenses such as:

- You can have wider lens apertures which will give better low-light performance as well as a shallower DOF (depth of field).
- You'll be able to choose more specialized lenses that will suit your needs like having ultra-wide angle lenses, extreme telephoto lenses, fish-eye lenses, and many more.

NOTE: To be honest, it is near impossible to make one lens that can do it all and can cater to each and every photographer's style.

But there are also disadvantages of using interchangeable lenses like:

- Need to carry more lenses if you want to shoot with different styles and range which makes it difficult to switch and be portable when shooting.
- Again, having the versatility of being able to change between lenses has a cost and that is changing the lenses. This might interrupt the rhythm of your shoot and can even affect how your images turn out.
- Each time you change your lenses there is a slight possibility of making your camera's sensor vulnerable to dust. This will greatly reduce the quality of your images and not to mention really hard to get rid of once inside.
- And of course, you pay a steep price for every lens that you buy.

Camera Sensor

Normally compact cameras have smaller camera sensors compared to digital SLR cameras. This is probably the most contributing factor that affects image quality when comparing these two types of digital cameras.

So how does this affect you as a photographer?

Price – Having larger camera sensors obviously mean that you will have to pay extra for that extra quality.

Size and Weight – larger camera sensors also mean that the body of your camera will have to be bigger to accommodate the size which in turn means that it will also be heavier.

Depth of Field – as stated earlier, having larger sensors also gives your camera a shallower DOF. This simply means better overall image quality.

Image noise – larger camera sensors also have larger pixels/photosites which means they have increased light-gathering areas and this translates to less image noise.

Dynamic range – thanks to larger pixels you don't have to worry about getting unwanted blown highlights from bright objects and not to mention that this also gives you more details when shooting in the shadows.

Other Minor Advantages and Disadvantages

We've already discussed the major differences between compact and digital SLR cameras. Now, here are some minor advantages of each camera.

Compact Camera

- Pre-programmed modes have better range
- Features a live view LCD (but newer digital SLR models now feature this as well)

SLR Camera

- Quicker camera autofocus
- Significantly less shutter lag (the delay when you press the shutter and start getting exposure)
- Much higher maximum frame rate
- Features RAW file format (newer compact camera models also have feature)
- Can take exposures up to 30 seconds with the help of manual/bulb mode
- Able to control exposure completely
- Able to use external flash unit (newer high-end compact camera models also have this feature)
- Has manual zoom control
- Greater range of ISO settings
- Not to mention you can buy a new camera and still keep your old lenses for use

NOTE: As you may notice, newer models are bridging the gap between both types of cameras. That being said, using high-end compact cameras can keep you at par with digital SLR cameras with newer models and features available.

All said and done, you need to remember a couple of things before choosing which type of camera is better. First, whether you would like to get flexibility and potentially get higher quality images and, consider the portability and ease of use of each camera. Last but not least, is to remember to choose the camera which is best suited to our needs.

Chapter 4

Camera Accessories

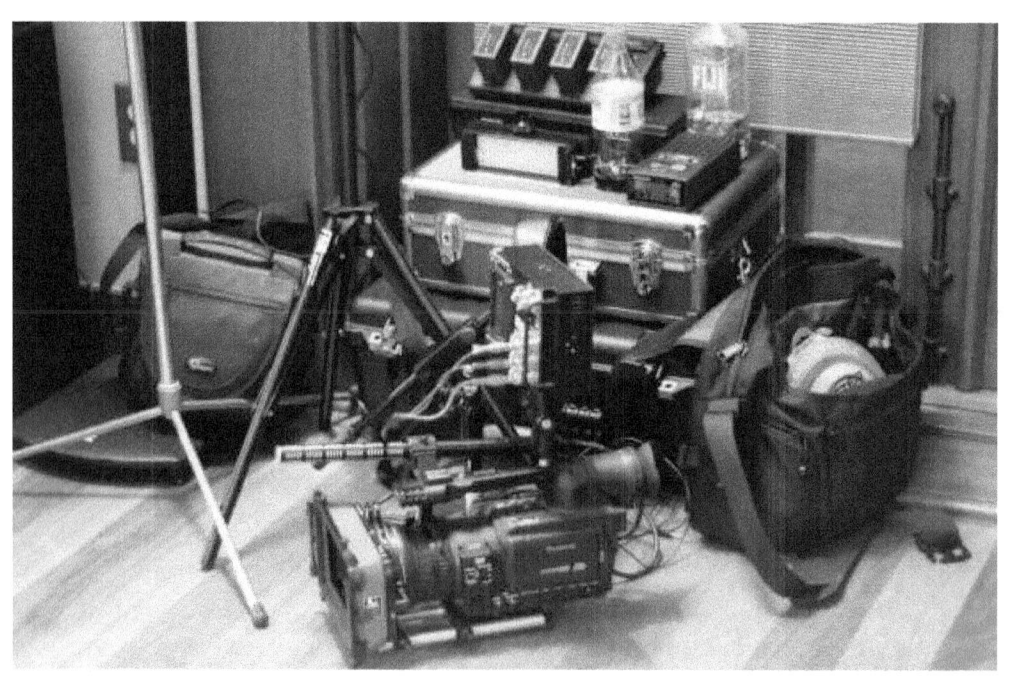

Having a camera is great and all but having the right accessories is definitely better. The most common accessories you'll get to use with your camera are the tripod, flash, lenses, and lens filters. You should know how to use each accessory to its maximum potential for the best results. Luckily we'll be doing just that!

Tripod

Having a trusty tripod around will definitely improve the quality of your images, especially in terms of sharpness quality. Not to mention that it also helps you get better depth of field, less light if necessary, and a lot more using special techniques and styles.

So When Do You Need To Use A Tripod?

The tripod's function is pretty obvious: hold the camera in place for maximum precision. This greatly reduces camera shake and in turn increases the image's sharpness.

One common rule of thumb when using the tripod is to estimate how fast you want to exposure to be or commonly called the focal length rule. This simply means that for a 35 mm camera, you'll need to set your exposure time to be at least as fast as one divided by the focal length in seconds.

For example, if you have a 100 mm focal length while using a 35 mm camera, you need to set the exposure time to be 1/100 seconds long at most. If you don't use this, the image will practically be blurry.

Other Common Uses for a Tripod

- When taking a series of pictures at different angles to create a panorama image
- When taking a series of pictures at different exposures for an HDR (high dynamic range) photo
- When taking time lapse videos and photos for animation
- When taking a series of pictures to take everything and make one whole image (including unseen background or subjects, etc.)

What to Consider Before Buying a Tripod

All this talk about tripods and nobody has mentioned how to choose the right one. Don't worry! I am here to help you all the way!

The stability or sturdiness of the tripod is one of the major factors you need to think about before buying one. Of course, the stability and sturdiness is influenced by the following:

- The materials used and how thick the legs are
- The length of the legs
- How many tripod leg sections there are

You should also consider the weight of the tripod when buying one. This will decide if you want a more portable and easy to set up tripod or a heavier yet more stable tripod.

There are also two types of tripod heads to choose from: the pan-tilt and the ball heads.

Pan-tilt heads give you more independent control since you can control each of the camera's axes of rotation namely the yaw (left-right) and the pitch (up-down).

Ball heads on the other hand give you more freedom in almost every direction and not to mention more compact compared to the pan-tilt heads. Of course having free movement in all direction has a cost and that is not having precise control compared to the pan-tilt heads. Ball heads are also most likely to be damaged easily.

Compact cameras also have tripods available, although they have very little versatility compared to the digital SLR's tripod choices and features. You can get either a tabletop or mini tripod for your compact camera which commonly only lets you change your yaw and pitch to a certain extent.

Camera Flash

Camera flash is one of the most common accessories you will find when it comes to digital photography. It is also one of the most misused and confusing tools for most photographers, especially for beginners.

It might seem easy at first glance, but using flash is different compared to just using the exposure feature of your camera. This is simply because using flash means that you will be shooting with two light sources as to one for exposure. The great thing about flash is that you have some control over it and you can change the way your subject looks just by using flash.

There are many techniques involving flash to greatly increase the quality of your image. Using flash to manipulate contrast is definitely a plus for any photographer since you can get higher quality images of your subject without over-exaggerating their features like facial features and so on.

For example, by aiming the flash away from the subject and using a bounced flash or a flash diffuser you'll get a "soft light" which is basically scattered light instead of a more concentrated and directional

light which is called "hard light". This enhances the image drastically and you don't get that much intensity from the light, but to achieve the same exposure levels successfully you need a stronger flash.

Positioning is also very important when using flash since it affects your subject's shadows and highlights. Taking a picture of your subject using head-on lighting will give you flat looking image compared to using an off-angle lighting which gives you more shadows and highlights that gives you a more three-dimensional look of the subject.

Of course there is also the dreaded red-eye which is mainly caused by flash. Flash frequently gives the effect of unnatural red-eyes caused by the glares from the subject's pupils. Thankfully, a lot of newer cameras today have a red-eye reduction feature that sends smaller flashes to prepare the subject's eyes of the incoming flash.

There are other methods of reducing red-eye; moving to a brighter environment or increasing ambient light. You can also use image editing software to remove red-eye, but this should be used as the last resort since it is a hassle compared to just adjusting the shot before it is taken.

Chapter 5

Camera Lenses

Camera lenses are vital when it comes to digital photography since you get more creative control. Therefore you should choose the right one while considering the following: cost, size, weight, and lens speed.

Did you know that camera lenses actually have various "lens elements" that all work together to give you the best possible results? The goal of lenses is to minimize aberrations as much as possible while still using inexpensive and lesser materials.

Your camera will be getting optical aberrations if the image is not properly translated while passing through the lenses. This causes blurry images, misaligned colors, distortion, vignetting, and loss of contrast.

Focal Length

This determines the camera's angle of view and how much of the subject will be magnified depending on the photographic position. This is why wide angle lenses have short focal lengths, while telephoto lenses have longer corresponding lengths.

Prime vs. Zoom Lenses

Zoom lenses can typically change their focal lengths within the pre-defined range. Prime lenses on the other hand are the exact opposite since they have a fixed focal lens. So what does this exactly mean?

Well zoom lenses are more flexible which means you can get a lot more varied shots making it great for children's photography and photojournalism.

Closer Look at Wide Angle and Telephoto Lenses

Wide Angle Lenses

Wide angle lenses are great for exaggerating the depth of your images and as well as increasing the relative size of it as well. But using one correctly isn't as easy as it may seem. Luckily this section will further discuss on how to take full advantage of wide angle lenses.

You need to get a lot closer to the foreground. This will help you immerse yourself with your subject and exaggerates the sizes of your subject, whether be it is near or far.

If you want clearer compositions you need to organize the near and far objects properly. There are a lot of techniques that take advantages of this such as organizing the subject matter into layers that are very visible that will help guide your eyes to the subject itself.

Since wide angle lenses can change the perspective of your image you need to remember to point your camera towards the horizon to avoid converging verticals instead of getting the accurate shot.

Last but not least is distortion. You should always remember to look at how edge and barrel distortion will affect your subject or target. Barrel distortion is when straight lines seem to like they're bulged. Edge distortion on the other hand is when the objects at the extreme edges seem like they are stretching away from the center of the image.

Telephoto Lenses

Telephoto lenses are commonly seen as the "super zoom" lenses, but in fact they aren't. They are more than that and they're a powerful tool for a skilled photographer since they can normalize the size between the near and far objects and as well as make the DOF shallower.

Another great thing about using telephoto lenses is that you can make it look like the spaces between objects are far more compressed to make the image look more congested. You can emphasize the appearance of congestion (a busy street or market) or emphasize more on the number of objects on the scene.

Of course the most common use for telephoto lenses is to bring small objects or subjects closer. This makes it great for wildlife photography.

Macro Lenses

These lenses specialize in taking macro or close up photos and can open up very exciting possibilities and perspectives for you and your audience. But knowing how to use this powerful tool is fairly difficult, especially for beginner.

There are a lot of factors you need to consider before getting a macro lens such as the sensor size and magnification, macro depth of field, effective f-stop, macro diffraction limit, focal length and working distance, and the overall quality of the close up image itself.

Camera Lens Flare

Lens flare usually happens when a non-image forming light passes through the lens and hits you camera's digital sensor or film. One of its most common characteristics is the polygonal shapes that appear. Although this can give you certain artistic style to an image, most of the time it is undesired so you need to understand how to correctly reduce lens flare and when to use it effectively.

The usual way to reduce camera lens flare is to use lens hoods. Getting the right lens hood can significantly reduce and even completely remove any chance of getting the lens flare effect on your images.

But you should remember to check if the inner parts of the lens hood use non-reflective material (e.g. felt) and there are no regions that are rubbed off.

You can also use lens filters that have an anti-reflective coating to reduce lens flare.

Camera Lens Quality

Nowadays, camera lens quality is more important since the latest and upcoming cameras today are getting bigger and bigger in terms of megapixels they can accommodate.

As stated in the previous chapters, the resolution of your images is limited by the quality of your camera's lens.

Chapter 6

Maintenance

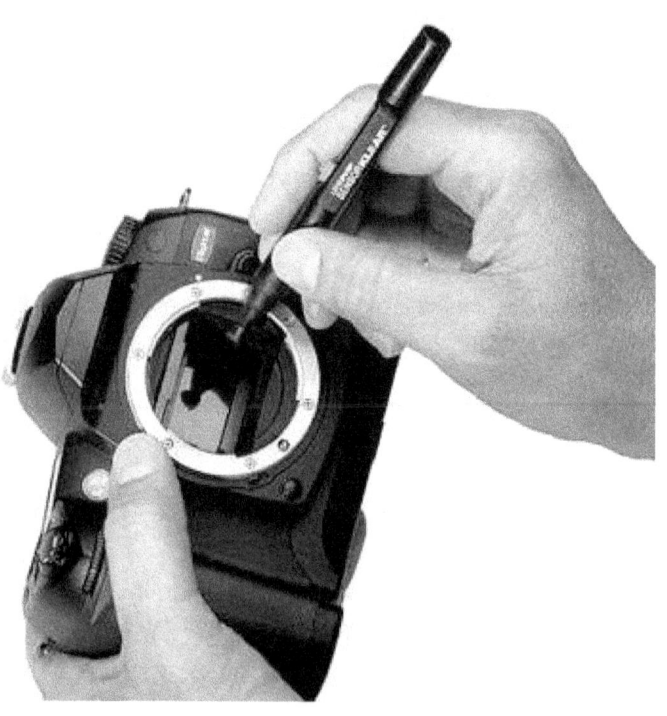

Having the right equipment for the job is essential in digital photography. But knowing how to properly take care of it is just as important. This section will discuss how to care for your different camera equipment and tools.

Cleaning and Taking Care of your Camera Sensor

The most common problems with digital SLR cameras are sensor dust which means that your camera's sensors are dirty. If you've never had this problem good for you, but sooner or later it will happen and it is better to be prepared.

Sensor dust is like spots on your viewfinder and images, but it can change depending on what type of dust it is. Not to mention that it also reduces contrast which also reduces overall image quality and sometimes you can't even see them since they are very minute.

Before doing anything to your camera and this applies to most of your equipment, you need to make that it really is sensor dust and where it is located.

For example, you might find dust on your viewfinder but you can't see it on the final image. You should look through your viewfinder and change the f-stop at the same time holding down the DOF preview button.

One tricky sensor dusts to find are the ones behind or in front of your lens. Try changing your lens to confirm if they have spots or not.

Of course the hardest to do is locating sensor dust since you run the risk of damaging your camera's sensor if you try to clean it. But it is helpful to know exactly how dirty the camera sensor is. There are 4 ways to go about this safely:

- Aiming your camera at a smooth, light background (white wall)
- Defocusing your lens to make the background look smooth and having no textures
- Applying a +1/+2 stop exposure compensation
- Last but not least is taking a picture using your lens's highest f-stop setting

Using the methods mentioned above, you'll get a clear look of where the sensor dust is located.

A word of warning; cleaning your camera sensor is very risky and expensive if it gets damaged so do it only if necessary. Otherwise you should go to your nearest digital camera store and get it cleaned by a professional.

Tips on How to Keep Your Sensor Clean

There's a saying that "prevention is better than cure", and it couldn't be more applicable when it comes to making sure that your camera sensor is dust free.

Minimize changing your lenses often to prevent dust from being introduced to your camera sensor and lenses. If you need to change lenses, make sure to do it in a clean environment with still air.

Also remember to point the camera sensor downwards or sideways when changing lenses to prevent dust from collecting on it.

Some new models of digital SLR cameras have self-cleaning sensor features built-in. Although it is very useful this feature doesn't remove all of the dust and they can still accumulate within your camera's body, sensor, and lens.

Chapter 7

Digital Photography Techniques and Styles

I've been helping you gain a lot of knowledge when it comes to how to handle your camera but now I am going to teach you the techniques and styles that professional photographers like me use. So buckle up and get ready!

Proper Camera Usage

Shutter Speed Creativity

Manipulating your camera's shutter speed can give your photos amazing results. You can give your images a "frozen in time" feel and look, convey movement, smooth water, and many more.

To explain further, your camera's shutter basically lets light through to start the exposure and close to end it, acting like a door or window. This basically lets you not just capture an image but also captures the light during the shot which helps you convey motion or lack of it.

Conveying motion

This can be a bit tricky and some may even say it is too restricted. But a lot of people find it very liberating, especially when it comes to still photography. There are a lot of creative ways to do this. For example, do you want the subject to get a defined blur or an unrecognizable streak of blur? You can even make your subject remain sharp while everything else is blurred or vice versa.

Take note of the following factors and how they affect your subject using certain shutter speeds:

- Speed – if your subject is moving really fast obviously it will appear more blurry.
- Magnification – if your subject occupies a larger portion of your image it will become more blurry. Luckily this factor is under your complete control by adjusting the focal length and subject distance.
- Direction of motion – if your subject is moving sideways it will be more blurry compared to moving away and towards the camera.

TIP: One neat trick is to slow down your camera's shutter speed to emphasize a stationary subject against a moving background or environment (person standing still among fast moving cars). You can do this by simply using about 1/10-1/2 second shutter speed.

Panning and Moving with your Subject

If you want to blur everything else and leave the subject sharp then you either need to have your camera moving with the subject or aiming your camera so that the image frames move together with the subject, this technique is commonly known as panning.

Let's try this out by taking a photo inside a moving vehicle or if you're looking for more excitement try one of the rides in an amusement park. Now keep in mind that you should adjust your shutter speed depending on the speed of motion as well as the stability of the moving object. So I would suggest you try $1/30^{th}$ of a second to start then adjust from there.

Panning doesn't mean that you have to make sure that your camera's speed is up to par with the speed of the subject's movement. You can just slowly pivot your camera and if the subject is far away a telephoto lens is really effective using this technique.

Also remember that you have to balance out the shutter speed to make sure that it is slow enough to make the background blurry while still be fast enough to make the subject look sharp. You can use an image-stabilized lens with the one-axis stabilization feature or better yet a tripod with a pan-tilt head.

TIP: Certain lenses use lens panning mode which is called "mode 2" on Cannon lenses. Nikon lenses on the other hand have VR or vibration reduction feature that automatically switch to panning mode if the motion of the lens is in one direction.

High Speed Photography and How to Freeze Time

Thanks to the latest advancements in technology new cameras are able to capture images in high speed like birds flying, rain water dropping down, sports, and so on.

Even with the right cameras and technology, high speed photography is still very challenging. One thing to remember is to be patient and anticipate the time you want to take the picture of your subject.

You also have to consider the "shutter lag" which is basically the delay between you pressing the shutter button and when the exposure actually starts. Digital SLR cameras usually have about 1/10-1/20 of a second shutter lag, but compact cameras on the other hand have a shutter lag as high as ½ of a second. **What you can do to reduce shutter lag is to pre-focus on or near your subject location.**

Other Creative Ways

There are other ways you can use shutter speed is to add the zooming blur or zoom burst effect. You can achieve this affect by simply setting up your camera on your tripod then having about 1/15-1/2 a second shutter speed, and finally twisting the lens zooming ring. Remember to avoid moving the camera too much to get a clean shot.

You can also add abstract effects; try using shutter speeds of 1/30-1/2 a second or even more. Then intentionally shake your camera to get an interesting and you can even call it an artistic blur to your images. Of course you have to do some trial and error before you get your desired effect.

More Tips

- *If you want a faster shutter speed, try using a lens that has a larger maximum aperture. You can also add more light to the scene by using flash or by moving to a brighter location.*
- *You can also get slower shutter speeds by using a neutral density filter or polarizing filter which blocks a bit of light.*
- *When trying the aforementioned techniques, remember not to over or under-expose the image and decrease the overall quality of the image.*
- *If you want to prioritize how your image conveys motion over DOF, then you can use the shutter priority mode. It basically enables you to pick your preferred shutter speed, while the camera's metering will adjust itself to get the best exposure available.*

Camera Shake and How to Reduce It with Hand Held Cameras

Camera shake is probably one of the most common problems affecting amateur and even professional photographers. This is more apparent when you are trying to take a shot using a hand held camera. But don't worry, I've got your back with some tips on how to reduce camera shake with hand held photos.

Camera shake is more prevalent when your camera's shutter speed is slow compared to the speed of the camera's motion. So to reduce camera shake you can do two of the following steps:

- Increase shutter speed
- Reduce camera motion

Increasing Shutter Speed

There are only 3 ways to increase your shutter speed:

Optimizing your exposure settings

When doing this you should consider what we call the triangle of camera exposure; depth of field (aperture), image noise (ISO speed) and shutter speed (motion blur). You'll be sacrificing one factor and gaining more of the others in your attempt to get better exposure.

Avoiding over-exposure

The most common culprit behind this is your camera's metering system which sometimes wrongly chooses a longer exposure time than needed. For example, having uneven indoor light can trick your camera to over-exposure.

Improve the lighting of your subject

You can either improve ambient lighting or use flash. For those who are using built-in flash for compact cameras, try going closer to your subject to get brighter illumination. If you don't have flash, you should try to go to a location with better light sources.

Tips on Improving Your Hand-Held Technique

Even though you can use a tripod and increase your shutter speed to get more accurate and sharper images, knowing how to take hand-held photographs is definitely a plus. This is especially true if there is a situation where you can't use a tripod or increasing shutter speed is not an option.

Plant Your Feet Firmly

This simply means that you have to brace yourself as well as your camera so that you will be in a stable and comfortable position to take a picture.

You can do this by sitting down, kneeling, leaning against a wall, or use your viewfinder rather than your LCD to give your camera more support. Remember to get at least 3 points of contact between your body and the wall or ground, or other objects you are using as a support for your body.

Get a Grip

Whenever using your camera, always remember to have both hands on it. Hold it firmly enough that you know it won't slip out of your hands but at the same time not so tense that you would get camera shake.

Also remember to place your arms close to your body for a more comfortable and stable camera grip and position. If you're using a large lens like a telephoto lens, you should always have one hand placed under the lens to support its weight while your other hand holds your camera in place.

Shutter Button Mastery

Practice makes perfect, especially in the case of getting better shutter button technique. First tip is to remember to always press the shutter button only half way and then you can press it with a little bit more speed and power (just a little bit more okay).

Taking deep breaths and exhaling half way while you press the shutter button also helps you stabilize your shot more.

Quick Fire Shots

By taking three quick shots in succession will help you get more options which of the photos you go with as your final product as to getting one shot and doing it over and over again if you don't like the quality or the look of the image.

A Couple More Tips

Lenses with vibration reduction (VR), image stabilization (IS), and cameras with shake reduction (SR) significantly reduce unnecessary camera movement. This is even more apparent and beneficial with telephoto lenses.

If you don't have a tripod, you can always use a flat and hard/stable surface like a table or the ground (just make sure you don't get any dust on your sensors and lenses). This will give your images unique and interesting effects and perspectives.

Chapter 8

Capturing Your Subject

Now let's move on to the techniques on how to capture your subject in different and difficult scenarios such as foggy, misty, and hazy environments.

You often see fog during mid or late evening and it even lasts to the next morning in some cases. It is also often found on locations that have water nearby since fog can form when the water is just a bit warmer than the air around it. Although I did mention haze and mist, the digital photography techniques used in fog are relatively the same for haze and mist.

The most common effects that fog will have on your photos are that the scenes won't have much contrast and color saturation and the scene including your subject won't that well defined and clear.

Think of fog as soft light or a natural soft box since it essentially distributes light in a way that the light originates from a much broader area. Of course, shooting with fog means that the area is most likely not well lit which means you need to compensate by using more exposure time than normal.

Fog also makes the air more reflective to light and this can trick your digital camera's light meter and it may automatically lower your exposure settings. So you need to compensate this by adding some more positive exposure.

But fog is not all gloom and doom, to say the least. It can also help you get more depth, lighting, and even emphasize the shape of your subjects more.

- Emphasizing depth with the help of fog is a "double-edge sword". This is because you can exaggerate the difference of near and far objects to great effect but lose contrast in the process. One tip on how to get better results when emphasizing depth is to get your subject or parts of your subject closer to the camera so you can get a little bit more contrast and color while still exaggerating the depth of everything else.
- As stated earlier, with the help of fog, light is scattered a whole lot more in the scene. You can use this to your advantage and emphasize light beams or rays to get an artistic effect. The thing to remember when doing this is that you need plan where your vantage point will be. With that in mind, you should be near the light source but not where it is exactly at. In doing so, you made sure you can get a clean and clear shot of the scattered light which is separated from the darker looking air.
- Fog can also greatly emphasize silhouettes and shapes. This is because in most cases, the fog will cover the entirety of the background and at the same time reflect more light. But be sure to set your exposure based on the fog and not base it on your subject to make your subject look like a silhouette.

NOTES:

- *Be careful of condensation collecting on your lens and inside your camera. This happens because of the difference in the temperature of the*

surroundings and your camera. To minimize this, you can simply put your camera and accessories in an airtight sealed plastic bag BEFORE going into a warmer environment.

- *You should wait a couple of minutes before you can take everything inside so that the plastic bag containing your camera and equipment will be at the same temperature as the outside environment (this can take as long as 30 minutes for larger camera lenses).*

Macro Photography Techniques and Tips

Close up photography, which is commonly referred to as macro photography is very popular among nature photographers and for a good reason. You can take your audience and viewers to a world where the normal human eye cannot. But it isn't as easy as zooming in up close to your subject. You need to learn proper techniques as well as careful attention to detail to get amazing quality macro photographs.

First thing to consider is how large your camera's sensor is. This is importance because the closer you get to your subject the larger it will appear and if you have a smaller camera sensor then you might only get a part of your subject instead of getting your subject entirely in the photo.

For compact cameras, they often feature "macro mode" which gives you the ability to get greater magnification and closer focusing distances. But if you are using a digital SLR camera, you have a lot of options like getting a macro lens or extension tube, and many more.

Also remember that when you magnify your subject, you also magnify the movement caused by camera shake. This is why you need to stabilize your camera with the help of a tripod and a remote switch or shutter release device.

Lighting is also very important when it comes to macro photography since it greatly affects the overall quality of your images. Here are a couple of pointers when considering lighting for macro photography:

- Front lighting – helps you get rid of unnecessary shadows and it gives a flat and 2D appearance to your images while lighting up everything that is visible
- Back lighting – this will emphasize the shape of your subject more and can even make silhouettes and give you a halo effect around your subject
- Side lighting – greatly enhances the subject's surface texture, gives more distinctive shadows, but the down side of using this lighting is that you hide every other detail behind the shadow created.
- Bottom and top lighting – this type of lighting is probably the most ideal if the light source has low contrast or properly diffused.

Night Photography Technique and Tips

Night photography has always been very challenging for photographers, especially if they don't have the right tools and knowledge to do so.

The main focus of night photography is the same as with daylight photograph. Although these factors are pushed to their extremes in night photography, you still need to consider the following – shutter speed, light sensitivity, and aperture. As you can see, the main factors of night photography are almost based on technology. Luckily, thanks to the latest advancements of digital photography you no longer have to go out on certain hours to get the best night shots.

One of the main factors to consider when doing photography at night is moonlight. This is basically the same with sunlight since certain angles of intensity and how light is reflected by the moon can create varying effects.

For example, if you are shooting under a low-laying moon you will notice longer shadows on objects that are cross-lit. But if you're shooting under an overhead moon it creates more intense and downward shadows.

Shooting under a fool moon is one of the best situations to be in if you do photography at night as you can reduce the exposure time required effectively giving you extended depth of field. Not to mention you'll also have increased visibility of the stars. But you should also pay attention to using the right exposure times during a full moon. One rule I go by if the subject is diffused and directly lit; is to use a starting point of f/2.0 and 30 seconds at ISO100 and then I adjust accordingly towards scenarios 1-4.

Using the viewfinder at night is also difficult since you only have little light available. One way to improve viewfinder brightness is to get a lens that has a large maximum aperture. Also by pressing the "depth of field preview" button you can manually choose which aperture you want and see what their differences are from each other.

Chapter 9

Lighting

Lighting in photography is one of the most important factors because you need to adjust a lot of things under different lighting scenarios.

Making Use of Natural Light

There are 3 major factors that affect how natural light will render a subject. They are as follows:

- Time of day
- Camera direction
- Weather conditions

Although it is obvious that natural light comes from the sun, the illumination of your subject depends on three components namely direct sunlight (warmer, high contrast), diffuse sunlight (cooler, low contrast), and bounced light (has qualities of the reflecting object like its color).

Notes for Time of Day

If you're shooting when the sun is closer to the horizon (high noon), then you'll get lower contrast since the light from the sun passes through more layers of the atmosphere yet it easily bounces off the ground towards the subject. Also take note that you can get an overall warmer light since the atmosphere filters more of the sun's blue light.

Notes for Weather Conditions

You need to consider cloud coverage just like when it comes to the time of day since it greatly affects the light variation. This is because clouds change the variation between diffused sunlight and direct sunlight which obviously affects the color temperature and contrast.

Tips on Portrait Lighting

Lighting is very important when you're talking about portrait photography. This type of photography is even easily identified by "everyday Joes". Portrait photography is not a walk in the park by any means and you'll be making several mistakes along the way

Portrait Lighting: One Light Source

The main or key light is the primary source of light for the subject. You can add more light sources once you've mastered key lighting which is performed independently from other light sources.

Always remember that distribution of light is the ONLY thing that directly contributes to the appearance of the subject when doing portrait photography.

With that being said, you can still mange the light distribution with the direction of the light and apparent size. The direction of light controls where the shadows and highlights will appear on the subject, while the apparent size controls how they will look like (have more intensity or contrast).

Although it may seem easy, mastering how to use these two main characteristics to control the distribution of light to your subject will give you amazing results.

Apparent Size: Soft Light or Hard Light?

This is probably the most common culprit of bad portrait photography.

NOTE: If you hear photographers talk about "hard" or "soft" light, this is actually just the size of the light source.

I bet you've heard of the term "too much of something is always bad" or something like that. This is true when it comes to apparent size since portrait photography benefits greatly from just using soft light (bigger light source) instead of hard light (smaller light source).

This is because a larger light source will span more of the subject in more angles. This also gives softer shadows and highlights. And using a smaller light source will have the opposite effect and will give your subject deeper shadows and highlights.

How to Get a Softer Light Source

- One great thing to do is get a diffuser. A diffuser is basically an object larger than the light source itself which has a translucent property. You can also use something like a lamp shade, an umbrella, or even just a curtain.
- You can also bounce or reflect the light source to walls or ceilings or move your subject farther away from the light source (open window, light fixtures, etc.)

Rembrandt Lighting

This classic technique is basically using one light source with a reflector to get the effect of an illuminated triangle right under the eye of your subject. You can do this by simply positioning your light source on one side of your subject at a 45° angle and place the reflector on the other side with the same angle. This classical technique gives your subject a natural and at the same time compelling look.

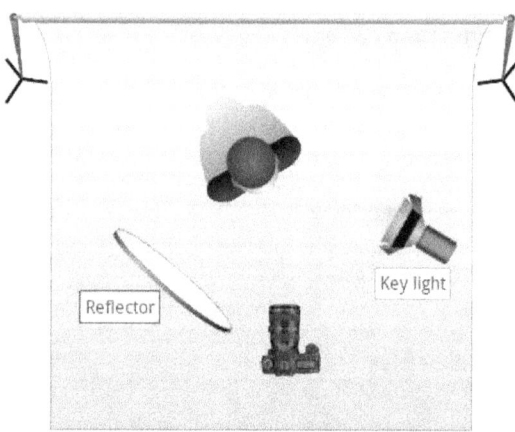

Common Rembrandt lighting set up

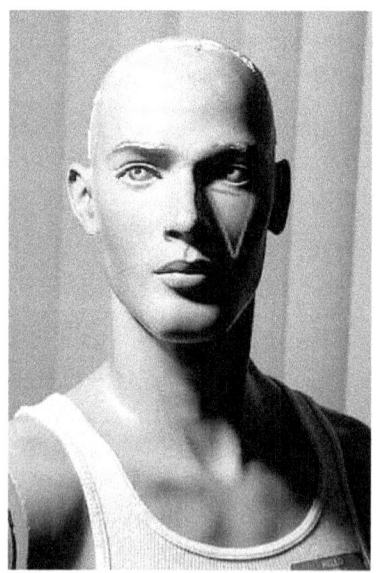

Rembrandt lighting triangle

Other Common Styles of Lighting Using One Light Source

- **Short lighting** – this is basically fully lighting your subject's face while leaving all the shadows at the near side of the head.
- **Board lighting** – is the opposite of short lighting; you will have to leave the shadows at the far side of your subject's face.

Chapter 10

Composition Photography

Composition photography is basically putting together your subject and the scene in a single frame to give a compelling meaning to your subject when viewed by other people. You can tell a good composition image when you know straight away what the focus of the image is and if you can't do so, and then this is an example of a bad composition.

There are a lot of techniques and styles to composition photography but for now I will teach you one of the most basic techniques – the Rule of Thirds.

Rule of Thirds

The rule of thirds basically tells us to divide your image into 3 parts horizontally and vertically. If you place your subject and other points of interest near the lines, especially where they cross, then you should have a more compelling image overall.

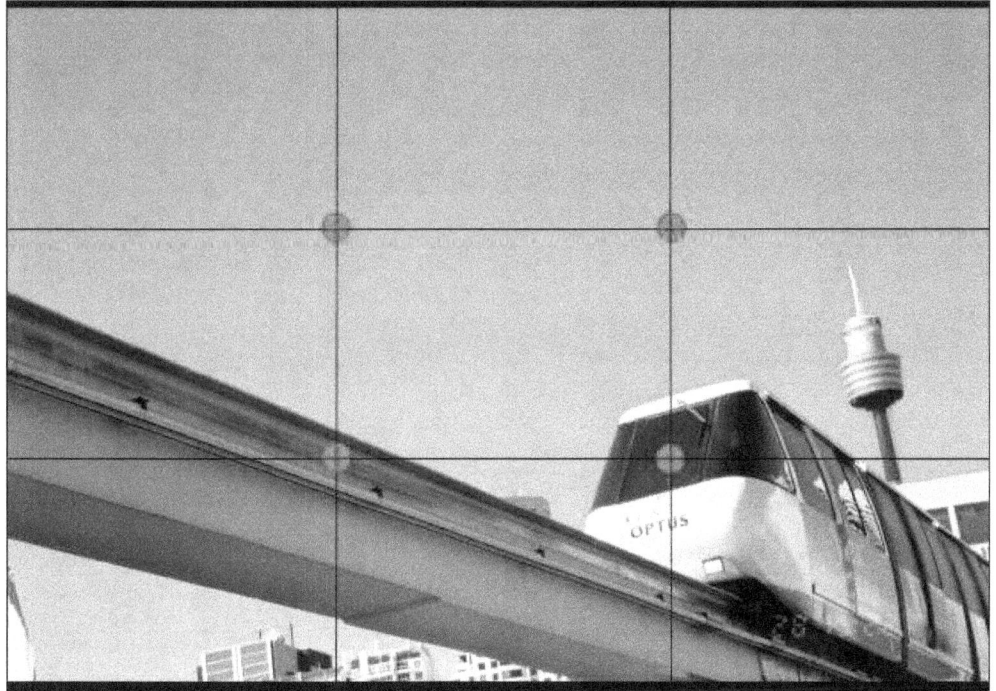

If you notice the image above, you can clearly see that the train is right on top of the intersecting lines, same goes with the train tracks. You'll also notice that the subject (train) and the tracks aren't centered; this gives your image a sense of motion or direction so to speak.

TIPS

- *Your subjects don't necessarily have to be on the intersecting lines, you can just place them near the lines.*
- *You can also edit out photos that didn't use the rule of thirds by cropping them on an image processing software to apply the rule.*
- *You are not bound by the rule of thirds. Once you've mastered this technique you can break it and learn how you can still get a good image composition without using it.*

Conclusion

We've finally reached the end of our journey on learning the basics of digital photography. I hope you've taken down notes and discovered amazing things while reading this e-book.

Remember that this e-book is a guideline on how to get better photographs using different styles and techniques. But also remember that you need to take advantage of the knowledge and understanding on the technical aspects of photography to improve your images.

Even though we have to part ways for now, don't feel down. Just like any journey, one ends so that another may begin. As a way of showing my gratitude to you, I have included chapter 1 of the next book in this series at the end of this book. I hope you like it! The next book in this series will be out very soon, so keep a watch out for that.

About the Author

Michael Hansen is a digital photographer based in his hometown Los Angeles in California. His works mainly focus on portraits, landscapes, and compositions. He has also worked with notable local photographers and his works were also featured in national newspapers and magazines.

He had a brief stint conducting photography workshops, but he decided to stop it since he didn't have the time between this and his work and because he wasn't reaching out to many people. That's when Michael decided to write an e-book to reach out to a larger audience and share his learnings on digital photography.

Acknowledgements

A big thank you to all the wonderful photographers whose shared images brought this book to life:

http://www.stockvault.net/photo/133444/lens-macro - terminology

http://morguefile.com/archive/display/73715 - lighting

http://www.unprofound.com/viewpic.php?pic=camera_equipment_panasonic.jpg&photographer=jim - accessories

http://openphoto.net/gallery/image.html?image_id=6195 - types of cameras

http://openphoto.net/gallery/image.html?image_id=22372 - camera lens

http://www.morguefile.com/archive/display/844112 - subject

http://morguefile.com/archive/display/86281 - composition

BONUS!

Book 2

Chapter 1

Introduction to Post-Processing Workflow

Photo editing can be a very difficult and stressful task to do, that is why you need a guideline to help you check your image's quality at the same time make the necessary adjustments without going back to previous ones. This post-processing workflow I am about to teach you is a general guide and is not necessarily required each time you want to edit your images since you just might want to edit certain mistakes or effects on your images.

The post-processing workflow is roughly in this order:

White balance > Exposure > Noise Reduction > Lens Corrections > Detail > Contrast > Framing > Refinements > Resizing > Output Sharpening

White Balance

Adjusting the white balance of your images can greatly improve the quality of your images, especially when it comes to overall colors, contrast, and color saturation.

Most cameras make mistakes on white balance when shooting in well lit scenes (even though this should give you more benefits than disadvantages). So be vigilant on monitoring the white balance of your shots in scenes such as low-light, indoor lighting, sunsets, and many more.

TIP: When adjusting the white balance settings, you first see the "temperature" slider which controls the warmth of the image and then the "tint" slider which controls the magenta-green shift.

Exposure

Even though you have done everything and I mean everything to get the best exposure before the shot, there will be times that the final outcome of the image will still get under-exposure or over-exposure.

Here are a couple of general tips that you can use in most photo editing software:

- Viewing your images at a smaller scale/size on your screen makes it easier for you to judge if there is over or under-exposure.
- Exposure has no "right" and "wrong" but it all depends on your artistic preferences
- Look for lost shadow details and blown highlights since it is a sign of extreme tones. Some image editing software can fix this using the "recovery", "fill light", and "black point" tools.
- Always remember that too much of something is bad. This is especially true for adjust exposure on your images. If you increase the exposure too much, image noise will appear and be more prevalent in shadows. If you decrease it too much on the other hand, you'll get more blown highlights.

Noise Reduction

You may have noticed that images taken with a high ISO speed will show much more noise. But don't worry since these images can greatly benefit from noise reduction using image editing software.

Here are some general tips on noise reduction using image editing software:

- Most people edit the noise reduction first before any other image editing adjustments. Of course the first two steps mentioned above are exceptions of this.
- Remember that there are many factors that affect image noise but thankfully noise coming from a high ISO speed is the easiest to adjust and edit out.
- Also keep in mind that it is better to reduce noise than completely remove it since some objects on your image might look unnatural in terms of texture.
- If your image has a lot of noise and not just from high ISO speed, then it is best for you to use dedicated noise reduction software such as Grain Surgery, Noise Ninja, Neat Image, and many more.
- Another thing to note that sharpness and noise reduction goes hand in hand. This is simply because they offset each other with sharpening increasing noise while noise reduction decreases sharpness.

Lens Correction

The most common and problematic yet correctable lens imperfections are vignetting, distortion, and chromatic aberration (CA).

Vignetting

Vignetting is when your image has reduced brightness or saturation compared to the center and is commonly found at the edges of your image.

If you're using low f-stops on your lenses then this is the most common problem for your images. Of course a touch of vignetting has its artistic uses since it can draw attention to your subject and certain things in your image.

Keep note that correcting vignetting will likely increase image noise on the corners. Also, if the vignetting is caused by your lens filter or lens hood then there is no way to correct this using image editing software.

Distortion

Distortion is when your image is distorted making objects and your subjects lose their original form. The two most common forms of distortion are barrel which makes it look like your image is spherical and pincushion which is the exact opposite of the former.

This is more common on images that use telephoto and wide-angle lenses. Again, be careful when correcting this and remember to only do it if it is clearly visible. This is because distortion correction can reduce the corner resolution of your image.

NOTE: Distortion also has artistic value especially when it comes to landscape photos, but it doesn't go the same way with architectural photos.

Chromatic Abberration (CA)

Chromatic aberration is simply a type of distortion where your camera lens couldn't focus all the colors correctly at the same place.

Like vignetting, chromatic aberration also appears most frequently on low f-stops and can be found mostly on areas of the images that have high contrast and near the corners of the image. Use the high contrast edge near the image's corner as a guide to correcting CA.

Details

This is mostly about sharpening, clarity and local contrast of the image. Most camera sensors give an inherent softening to your image making it blurry and have fewer details than intended. With that being said, sharpening your images should be done moderately since you'll be doing more sharpening that we will discuss later on this guide.

Sharpening your images is important since it can worsen image qualities like noise, CA, and so on.

Contrast

The most common cause of low contrast in images is when you are shooting with a bright indoor light or into the sun. Correcting the contrast levels of your images will give your images that 3D look and make them "pop" so to speak.

Notes:

- *Too much contrast will make your images and subject look unrealistic*
- *Higher contrast levels also give the colors of your images a more saturated look*

Framing: Cropping and Rotating Images

Using proper rotating and cropping of your images will greatly enhance them and this is especially true to composition photos. Although there are many rules about this, you can start off by reading the Rule of Thirds on the previous e-book.

POINTERS:

- Remember to match the crop of your images to the print size of your photos.
- Great thing about most photo editing software is that they have a feature that can specify the aspect ratio of your crop which makes it easier to do so.

Refinements: Colors and Selective Enhancements

Selective Enhancements

This is all about removing spots and blemishes on your images, selective noise reduction, and creative sharpening.

There are plenty of tools that can help you with selective enhancements such as clone tool, healing brush, adjustment brushes, and many more.

Colors

If you have correctly set the white balance, contrast, and exposure there is little need to adjust the color saturation, vibrance, and other color adjustment settings.

NOTE: If you've applied any of the changes mentioned above, you should make a back up copy of your image. This is because the following steps will only determine how you will share your photo. So with that being said, the image after all the changes made should be final.

Resizing

When resizing your image, you typically want to upsize for prints and downsize for web.

Upsizing

- Also remember when enlarging for prints that you should do it yourself manually instead of using the printer to enlarge it. This is because using the printer to enlarge your image might give your image an unwanted pixelated look.
- Haloes on sharp edges of your image might indicate that you did too much sharpening to your image.

Downsizing

- When downsizing your image for web usage or sending it via email avoid using moiré artifacts and other non-image patterns.

Output Sharpening

Finally, the last image editing step you want to apply on your image – Output sharpening. The reason for this is because you need to customize the level of sharpness depending on the output device you are going to use. Factors you need to consider are the size of the image, and the type and viewing distance of the image.

www.ingramcontent.com/pod-product-compliance
Lightning Source LLC
Chambersburg PA
CBHW071640170526
45166CB00003B/1379